Greco-Roman Gods And Heroes At The Doors Of The San Francisco Asian Art Museum

Janet C. Constantinou

authorHOUSE®

AuthorHouse™
1663 Liberty Drive
Bloomington, IN 47403
www.authorhouse.com
Phone: 1 (800) 839-8640

© 2019 Janet C. Constantinou. All rights reserved.

No part of this book may be reproduced, stored in a retrieval system, or transmitted by any means without the written permission of the author.

Published by AuthorHouse 12/26/2018

ISBN: 978-1-5462-5894-0 (sc)
ISBN: 978-1-5462-5893-3 (e)

Print information available on the last page.

Any people depicted in stock imagery provided by Getty Images are models, and such images are being used for illustrative purposes only. Certain stock imagery © Getty Images.

Diana of Versailles
Image credits to Nita Jatar Kulkarni.

Ajax with the corpse of Achilles,
Wilhelm Heinrich Roscher
Gottingen, 1845-Dresden, 1923
"Greek Mythology Link www.maicar.com"

Amphitrite
Francois Devaulx
© Marie-Lan Nguyen / Wikimedia Commons

Neried on a sea-monster
"Greek Mythology Link www.maicar.com"

Eirene and Ploutos
Jan van der Crabben / Ancient History Encyclopedia (www.ancient.eu).

This book is printed on acid-free paper.

Because of the dynamic nature of the Internet, any web addresses or links contained in this book may have changed since publication and may no longer be valid. The views expressed in this work are solely those of the author and do not necessarily reflect the views of the publisher, and the publisher hereby disclaims any responsibility for them.

We know enough to make up lies
which are convincing,
but we also have the skill, when
we will, to speak the truth.

The Muses to Hesiod. Hesiod, *Theogony* 25

Contents

Acknowledgements .. 1
Introduction ... 2

Athena ... 4
Artemis .. 8
Menelaus With Patroclus 10
 Priam With Hector ... 10
 Aias With Achilles .. 10
Eirene And Plutus Morphing To
 Madonna And Child 14
Heracles .. 18
Perseus With Medusa's Head 20
Amphitrite .. 22
A Nereid .. 24
The Muse Terpsichore Or Erato 26
Pan .. 28

Epilogue .. 31
About The Author .. 33

Acknowledgements

Many generous friends have given valuable input and inspiration to bring these ideas together. It all started with the simple question "Who are these images at the museum entrance?" The answers have come through discussions with Margaret Austen, Lesley Bone, Adonis Constantinou, Ilias Chrissochoidis, Jody L. Maxmin, John and Catherine McGilvray, Paula Rampe, Rachael Seeley, Sunny Scott, Eve Siegel, William Strawn, and my ever loving and patient family Sophie Constantinou, Phil Constantinou, grandchildren Milo Rex Constantinou Tredway and Catherine Constantinou Pertle and my dear husband Chris Constantinou. The San Francisco Main Library staff, particularly Thomas Carey and Andrea Grimes, provided helpful information and suggestions. The security guards at the Museum doors showed interest and gave input.

Introduction

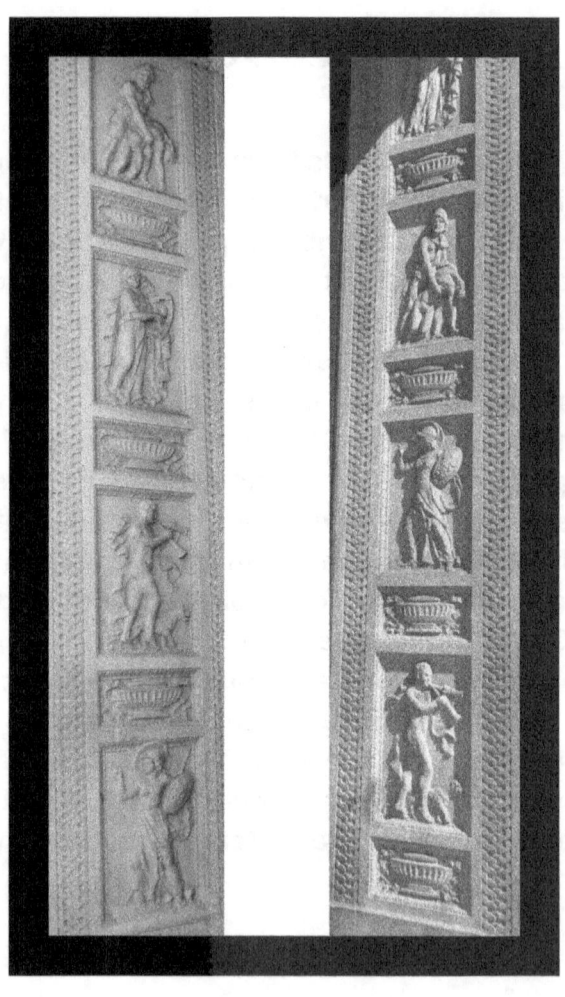

These Greco-Roman images are in bas-relief inside the façade of the three main entrances, and one side entrance to the Asian Art Museum at 200 Larkin Street, San Francisco.

This work is an attempt to identify the images and their source of inspiration, and to fathom the meaning that they may have conveyed to the people of San Francisco at the time of their selection.

The building was designed by architect George W. Kelham (1871-1936) and built by John Duff McGilvray (1847-1916) and his son John Duff McGilvray Jr. It was first opened in 1917 as the San Francisco Main library. The Greek bas-relief ornamentation is typical of the Beaux-Arts style, which is a combination of Greek and Roman classical architecture modified to meet the needs of the times. George Kelham studied at the Ecole des Beaux Arts in Paris where this style was very popular at that time.

Athena

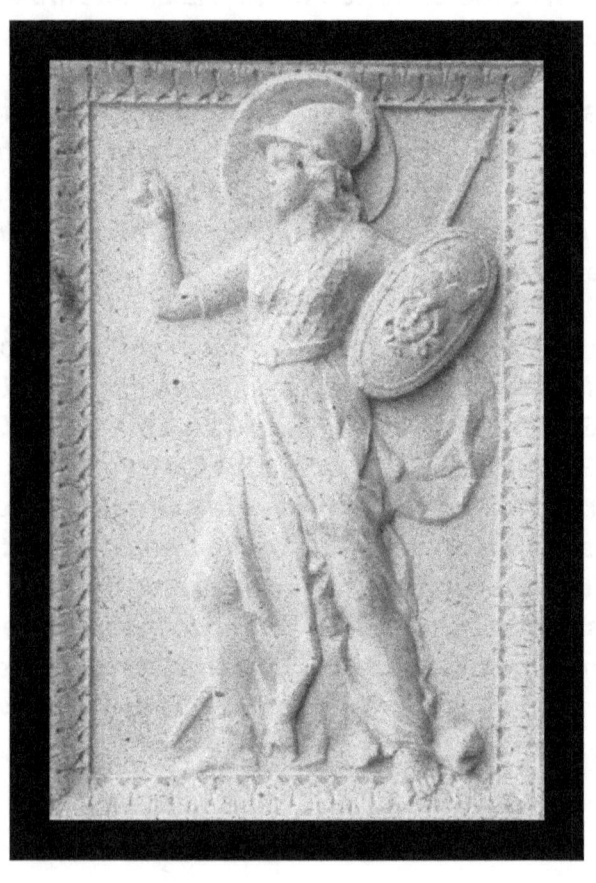

Athena was the daughter of the supreme god Zeus of ancient Greece. The Romans called her Minerva. Athena was born fully-grown from her father's head. She is known as the protector of cities; Athens and San Francisco are two such cities. She appears on the Great Seal of California symbolizing a State that started out fully-grown, like Athena herself.

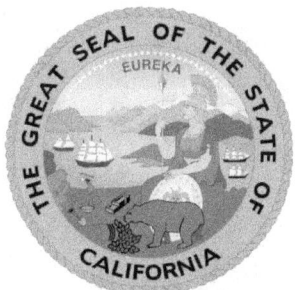

California seal

Thanks to the Gold Rush in 1849 California's population quickly grew and so it was not necessary to transition through the probation period as a Territory. California became a State of the Union in 1850. The Pioneer Monument standing adjacent to the Asian Art Museum, dedicated in 1894, displays a large statue of Athena atop a decorative pedestal as a testament to her role as protector.

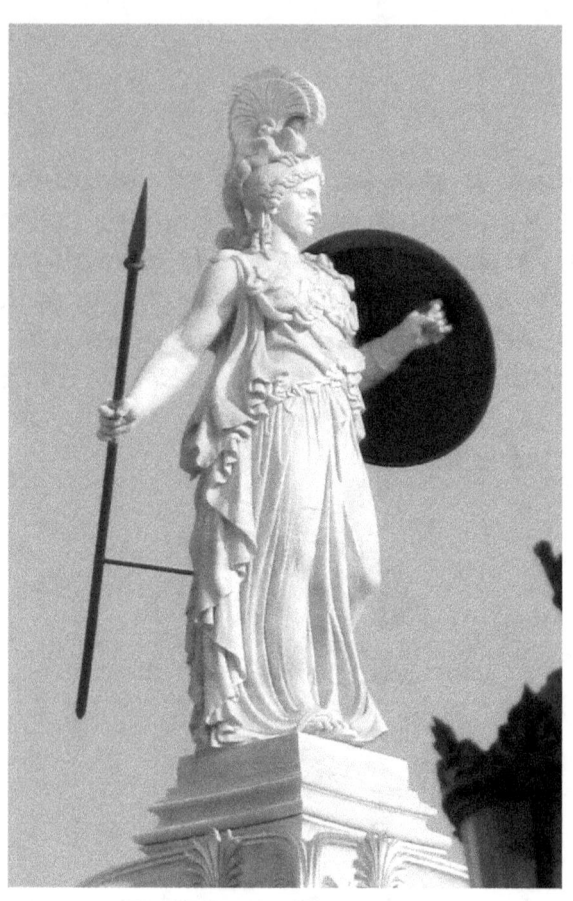

The Pioneer Monument

Athena is credited with being a warrior goddess of just wars and is frequently depicted with a long spear and a shield emblazoned with Medusa's head. More will be explained about Medusa and her hair when the story of Perseus is told.

Just wars require wisdom, and this is one of Athena's great qualities. A symbol of wisdom is the owl and this can frequently be found sitting on Athena's shoulder.

The people of San Francisco were reminded through these images that their safety was in the hands of a very powerful wise woman.

Artemis

Artemis, named Diana by the Romans, was another daughter of Zeus. She was the twin sister of Apollo. Known as Goddess of the hunt, and of chastity. Artemis' symbols are a quiver of arrows, a stag and a short skirt.

The depiction of Artemis on the Asian Art Museum façade appears to be inspired by the Roman sculpture of Diana of Versailles (1st-2nd century CE), now in the Louvre, Paris. This was a Roman copy of a Greek sculpture by Leochares who lived in Athens in 4th century BCE.

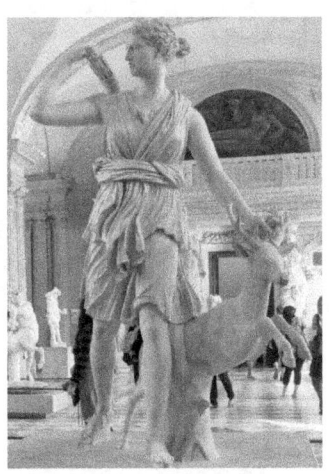

Diana of Versailles

Menelaus With Patroclus
Priam With Hector
Aias With Achilles

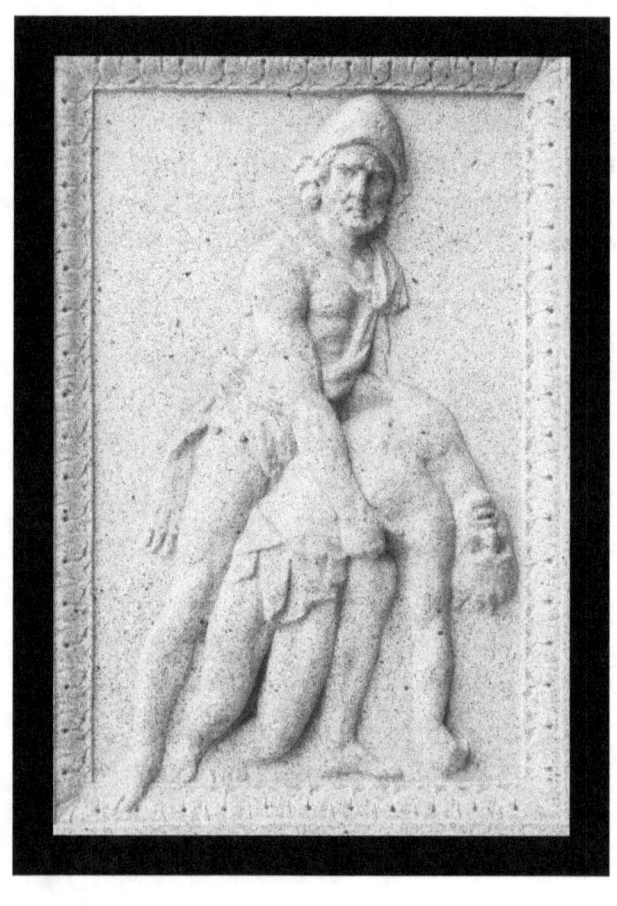

The message of compassion is clear in this image, but the confusion as to the exact identity of the pair comes from the fact that a Greek bronze depicting such a scene was made about two centuries before the common era (BCE). This has been lost, but many Roman copies were carved in marble and much later molded in clay. A Roman sculpture of this scene stands in the Loggia dei Lanzi beside the Uffizi Gallery in Florence and is declared to be either Menelaus with Patroclus or Priam with Hector.

Priam was the King of Troy during the Trojan wars. Paris was his son who went to Sparta and captured Helen, the wife of the Greek King of Sparta, Menelaus. Paris brought Helen back to Troy and married her. This started the Trojan Wars as Menelaus attempted to reclaim his wife from Troy with the help of Greek armies from many areas of Greece.

Menelaus was assisted in battle against the Trojans by two great warriors, Achilles, and his close friend and brother in arms, Patroclus. Patroclus was killed in battle by Hector who was the brother of Paris, and another son of King Priam of Troy. Ceremonial burial was an important part of religious beliefs of the time.

King Menelaus is said to have carried Patroclus, his loyal Greek warrior, from the battlefield for this purpose.

Hector was much loved by his father King Priam. Achilles killed Hector and mutilated his body in anger, still grieving the loss of his dear friend Patroclus. It was imperative to Priam that his son, Hector, should have an honorable burial, so the proud Trojan humbled himself before the Greek Achilles and pleaded to be allow to take his son home for burial. Achilles took pity on the old man and allowed him to take Hector, and suspended the war during the funeral ceremonies. Priam is said to have kissed the hand of Achilles, the enemy, as a gesture of gratitude for the compassion shown by Achilles.

Aias was called Ajax by the Romans. Aias and his friend Achilles were Greek heroes and warriors in the Trojan War. Achilles was killed in battle by an arrow shot by Paris to his vulnerable heel. Ajax carried his friend's lifeless body from the battlefield.

These are all stories, told in the Iliad, of great tenderness shown by strong men in the event of death in battle.

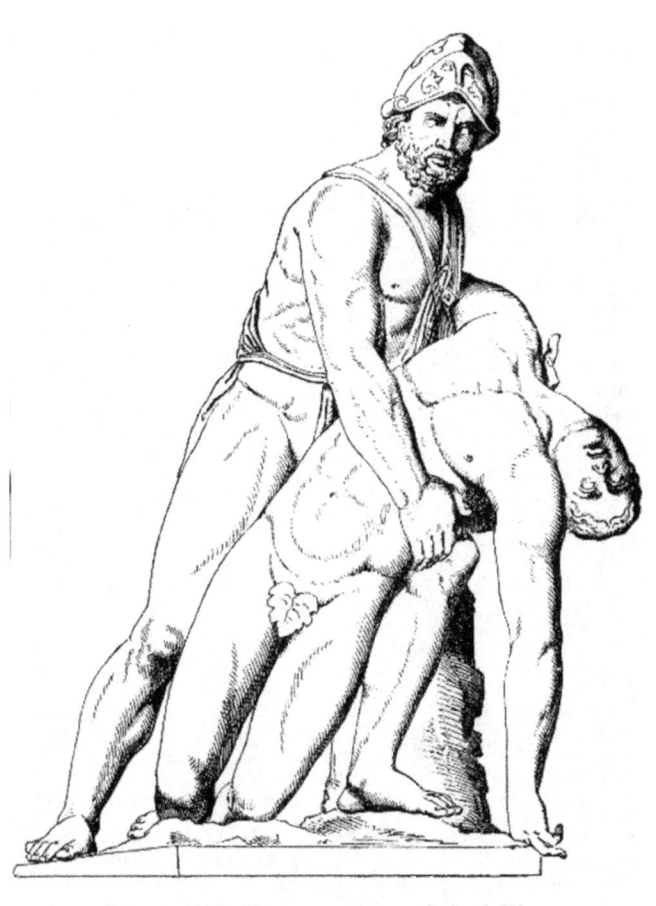

**Ajax with the corpse of Achilles,
Wilhelm Heinrich Roscher
Gottingen, 1845-Dresden, 1923**

Eirene And Plutus Morphing To Madonna And Child

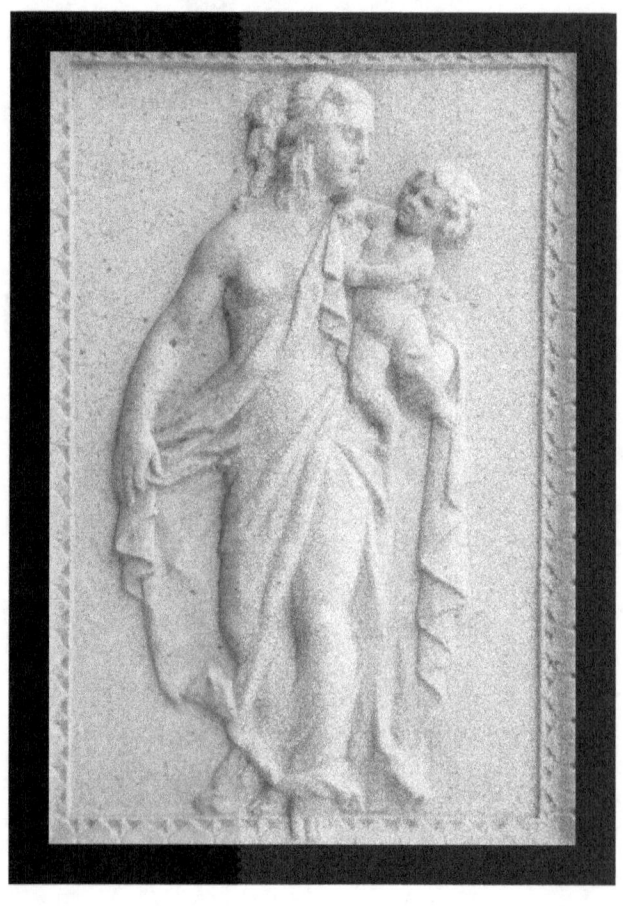

Eirene was the goddess of peace, known as Pax by the Romans. In her arms she holds Plutus the god of wealth. Peace embracing wealth was surely a symbolic message that would be pleasing to the San Franciscans. Below is an image of a Roman copy of a Greek Bronze 375-370 BCE. Glyptothek, Munich

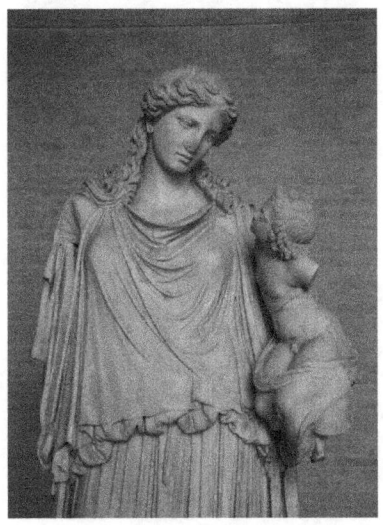

Eirene and Plutus

However, there are many portrayals of Eirene but not with one bare breast. The bas-relief at the doors is more representative of the Madonna and Child, particularly as in Mary of the Milk. This is a common image found in many Catholic churches.

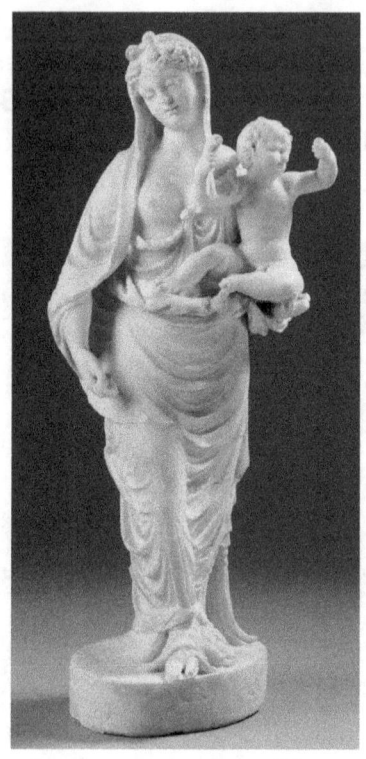

*Madonna and Child
Victoria and Albert Museum, London*

Stonecutters and journeymen had come to San Francisco in large numbers from Catholic European countries, particularly, Italy, France and Ireland at the turn of the 20th Century.

Taking the liberty to embed the Madonna in their work may not be surprising. Just as the Romans have copied the Greek works and renamed them to fit their beliefs, the Catholics of San Francisco may well have done the same.

Heracles

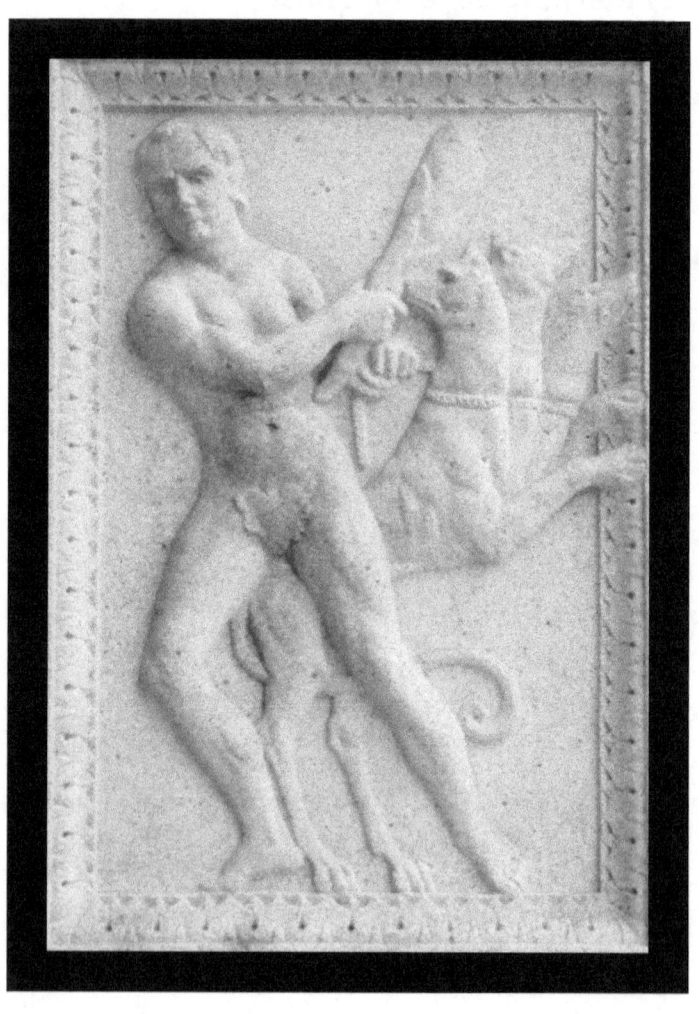

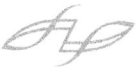

Heracles, who was called Hercules by the Romans, was a major hero. A son of Zeus, Heracles was the strongest man on earth. He is depicted with Cerberus, a multi-headed dog who was guardian at the gates of the underworld. Heracles was challenged with 12 labors. The final one was to bring back Cerberus from the underworld. As Greek beliefs spread to Asia, Hercules was adopted as a protector of the Buddha and named Vajrapani.

Heracles as Vajrapani with Buddha
British Museum

A strong man like Hercules, able to overcome all challenges that he faced, was the kind of hero that men arriving in the Wild West would find inspirational.

Perseus with Medusa's Head

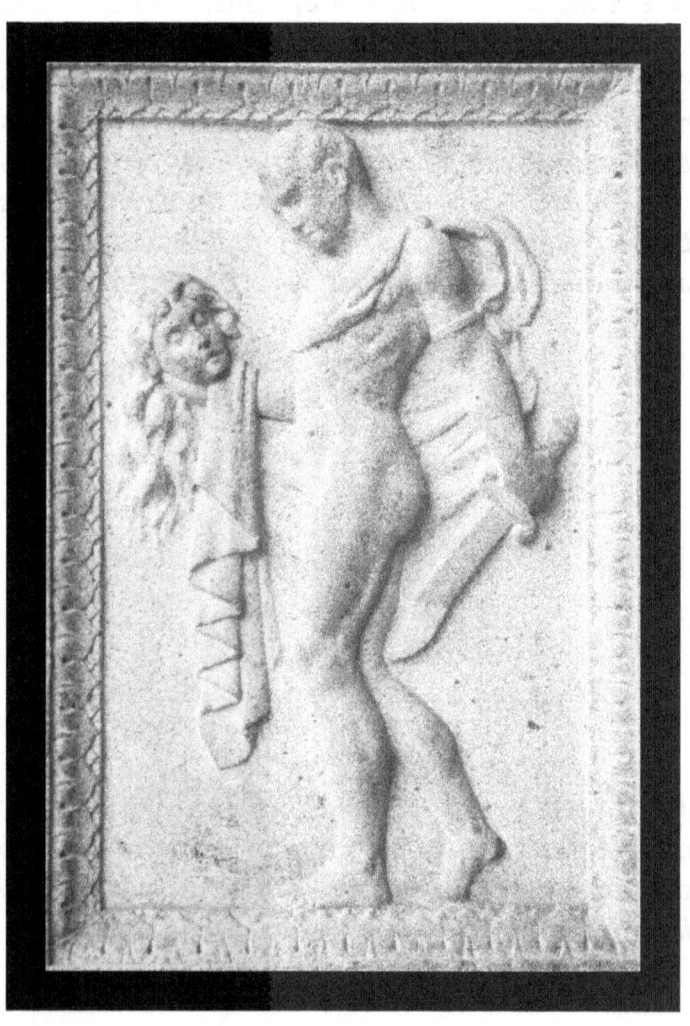

Perseus was another son of Zeus and is shown here with Medusa's head.

Medusa, a Gorgon, is said to have been very vain of her beautiful hair, and was admired by Poseidon. Athena changed Medusa's hair into hideous snakes because Medusa and Poseidon are said to have made love in Athena's temple, violating the sacred space. Athena's shield is decorated with Medusa's head as a reminder of her powers.

Perseus was challenged to bring the head of Medusa to Polydectes, his mother's lover. This was believed to be an impossible task, but Perseus was helped in his quest with several gifts from the gods. One was a knapsack for Medusa's head and another was a sword called a harpe. Both gifts can be seen on the image of Perseus. He was also given a helmet that made him invisible, winged sandals so he could fly, and a polished shield to shine light in the eyes of his pursuers.

Amphitrite

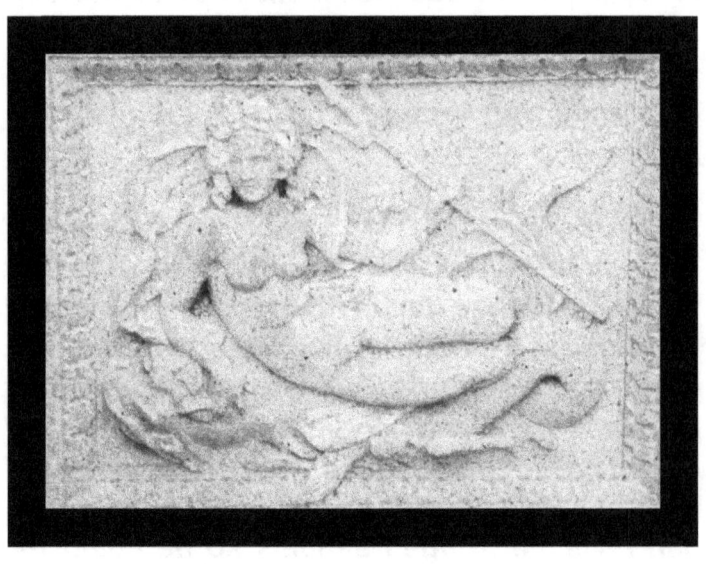

Amphitrite was the wife of Poseidon. Poseidon (Roman name Neptune) was the God of the seas. Amphitrite is frequently portrayed with a trident, and riding on a sea creature. The trident is embedded in her name and is shown in her image. Francois Devaulx created a fine statue of Amphitrite in Paris, in 1866. George Kelham, the architect, graduated from the Ecole des Beaux Arts in Paris in 1896, so he was probably familiar with this famous statue.

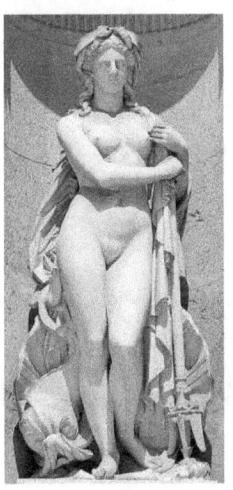

**Amphitrite
Francois Devaulx**

A Nereid

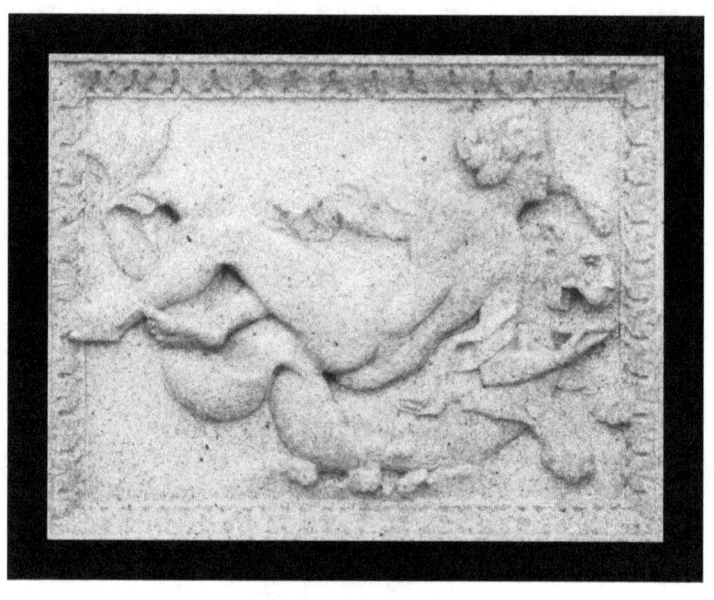

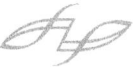

Nereids are sea nymphs, female spirits of the sea. They often accompany Poseidon, the god of the sea, and his wife Amphitrite. This Nereid is riding a sea creature to the wedding of Poseidon and Amphitrite, and carrying a gift in her hand. This wedding scene is carved on the Frieze of the Altar of Domitius Ahenobarbus, 2nd C BCE, now in the Munich Glyptothek, Germany.

The bas-relief around the museum door is a very close copy of an illustration from The Classic Myths by Charles Mills Gayley who published this book when he was a professor at the University of California, Berkeley in 1893.

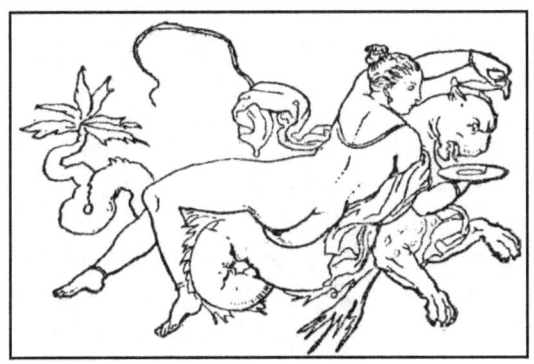

Nereid on a sea-monster

The Muse Terpsichore or Erato

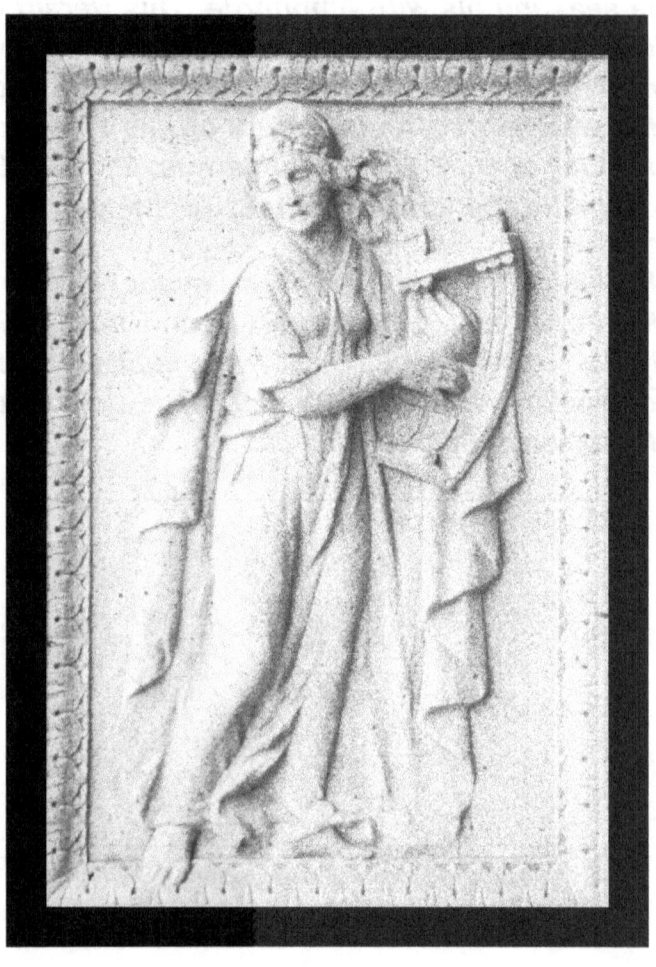

Terpsichore and Erato are Greek muses of dance, music and poetry. They are usually depicted with a lyre, which is sometimes called a kithara. They both inspired musicians and poets such as Homer. Since museums and libraries hold the works inspired by the muses the doorway is a very fitting place to find a muse.

PAN

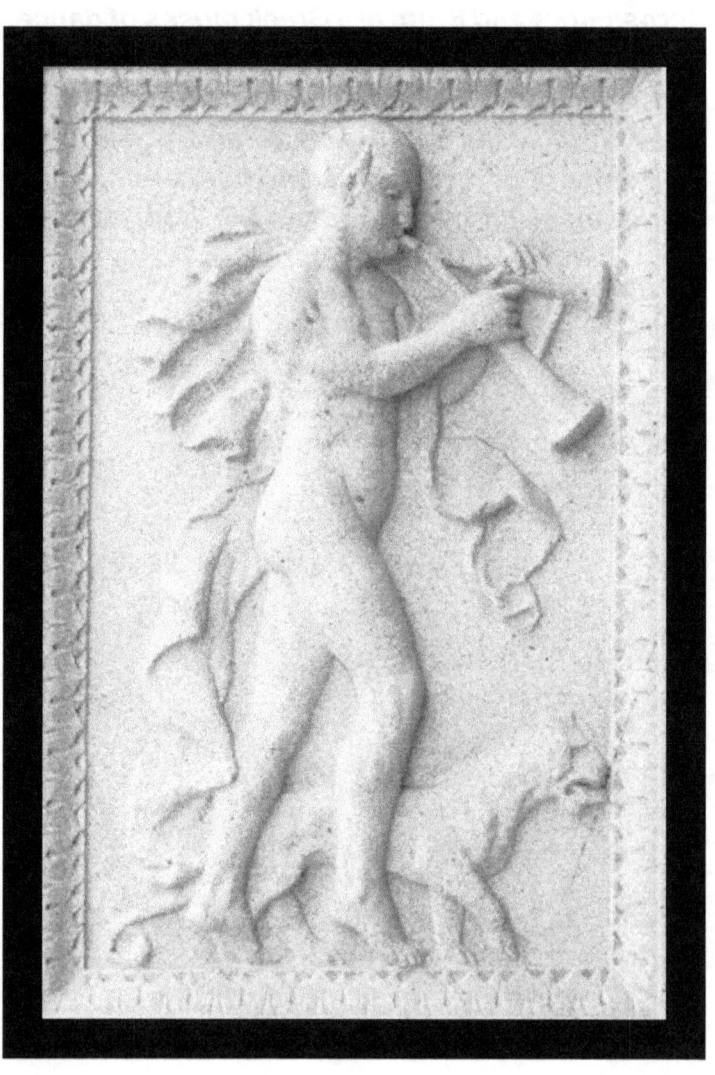

Pan is depicted with pipes and a leopard. He is often shown with goat legs and ears. His Roman name is Faunus.

He was a god of nature and the woodlands and a companion to the nymphs of the forest.

Epilogue

The images chosen to decorate the original City Library appear to be sending messages of good will to the people of San Francisco. Athena is here to protect the city. Artemis is symbolizing a message of good hunting at a time when people provided food for their families in the nearby hills. The powerful warriors show compassion to their fellow man by carrying their bodies from the battlefield. Eirene and Plutus represent peace and prosperity; that was surely a dream of many immigrants coming to San Francisco. Hercules is the strong man and Perseus can achieve the impossible. Many new immigrants to San Francisco could have found inspiration from these great heroes. As a city on the bay and beside the ocean, sea nymphs and spirits of the sea could be a comfort to fishermen and sailors. Finally there is motivation for the arts. The muses enkindle creativity in dance, poetry, writing, art and sculpture. All topics covered in the library and still on show at the museum today. Pan is piping music as he takes off into the wilderness. All of these ancient Greek figures were probably selected to inspire those who passed through the doors of the former San Francisco Library and now the Asian Art Museum. Would Mary of the Milk have been such an inspiration?

About The Author

Janet Constantinou, Ph.D. spent her working career pursuing medical research at Stanford University Medical School. On retirement she began to study the arts, and trained as a docent at the Asian Art Museum. In this role, her great pleasure was to introduce students to the wonders of the Museum. It was the curiosity of a student that prompted the investigation that lead to this book. She lives at Stanford with her husband and loves time with her children and grandchildren.

www.ingramcontent.com/pod-product-compliance
Lightning Source LLC
Chambersburg PA
CBHW061228180526
45170CB00003B/1208